Contents

C000109231

Introduction

I have been taking photos since 1980. I had a variety of jobs in London at the time that involved walking around the streets and visiting places, and I would look at the architecture.

Even then London was constantly changing and evolving, so I set out to try and capture some of what was being lost.

I had no intention at the time of making my photos public, and when I started it would have been difficult anyway, but once the internet came into general use I realised it was possible to display them. The interest in them slowly grew, but originally people didn't understand them at all. I use Flickr as the main outlet for my images, but of course once the photos are out there I lose control of them. Pixsy shows the odd corners of the world that they turn up in.

I worked on the London Underground for around twenty years, which gave me access behind the scenes and provided the opportunity to take photos. Nowadays, I visit London for recreation purposes rather than for work.

I have taken pictures in other places and countries too. My photos appear regularly on Facebook and Pinterest, as well as in other people's books. One was in Oliver Green's book about Liverpool Street Station, *Terminus*, and Liberty Smith made a short film called *My House Exploded* about what happened to her childhood home in the 1980s in Colville Road, Leytonstone, E11. My photos were the only known images of the façade of her house; I had taken photos there due to the construction of the M11 link road (A12) and the protests against the demolition of 300 houses. A TV series called *Jay Blades' East End Through Time*, about the London Docklands/East End, also featured a couple of my photos.

I have been encouraging my daughter to take over from where I leave off, though I hope to continue photographing for many years to come.

LOST LONDON

TIM BROWN

AMBERLEY

First published 2024

Amberley Publishing
The Hill, Stroud
Gloucestershire, GL5 4EP

www.amberley-books.com

Copyright © Tim Brown, 2024

The right of Tim Brown to be identified as the Author
of this work has been asserted in accordance with the
Copyrights, Designs and Patents Act 1988.

All rights reserved. No part of this book may be reprinted
or reproduced or utilised in any form or by any electronic,
mechanical or other means, now known or hereafter invented,
including photocopying and recording, or in any information
storage or retrieval system, without the permission in writing
from the Publishers.

British Library Cataloguing in Publication Data.

A catalogue record for this book is available from the British Library.

ISBN 978 1 3981 1740 2 (print)
ISBN 978 1 3981 1741 9 (ebook)

Origination by Amberley Publishing.
Printed in the UK.

Central London

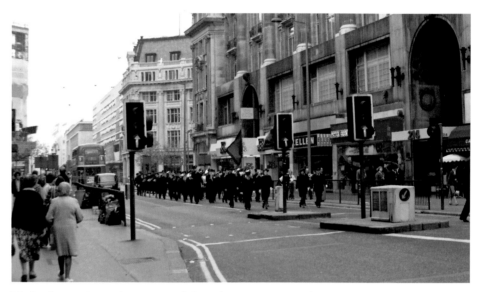

It's Sunday 28 September 1980 and the Salvation Army Band are marching past Top Shop on Oxford Circus.

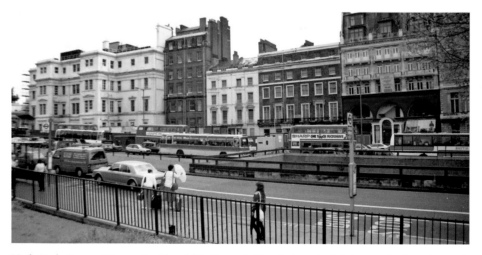

Hyde Park Corner, May 1987. The old St George's Hospital on the left is now the Lanesborough Hotel and the buildings between it and the Underground station have been replaced.

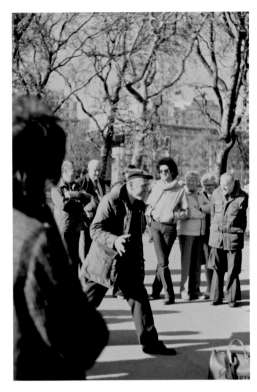

Speakers' Corner, Hyde Park, April 1981.
This man was known for his version of the
'Ministry of Silly Walks'.

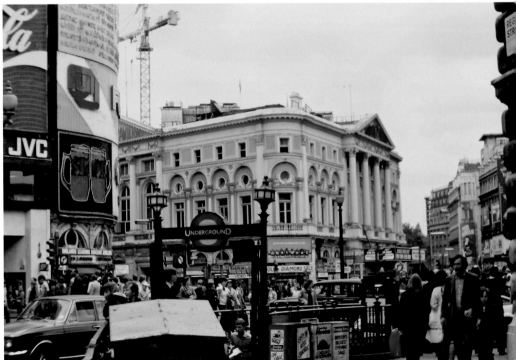

London Pavilion, Piccadilly Circus and Shaftesbury Avenue, May 1981.

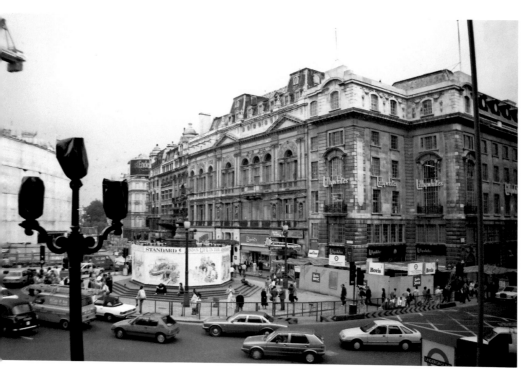

Piccadilly Circus undergoing redevelopment, June 1987.

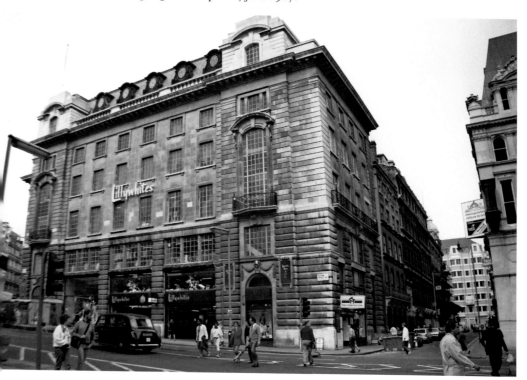

The Lillywhites/Criterion site at Piccadilly Circus just before redevelopment in May 1987.

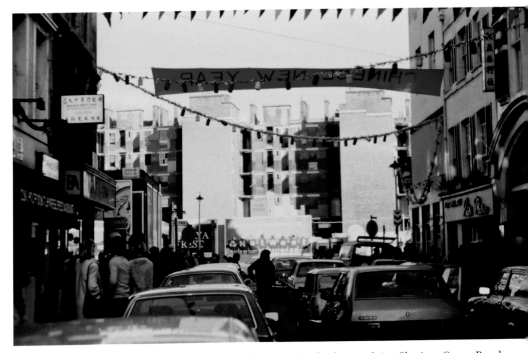

Chinatown in February 1981, before the buildings in the background in Charing Cross Road were demolished.

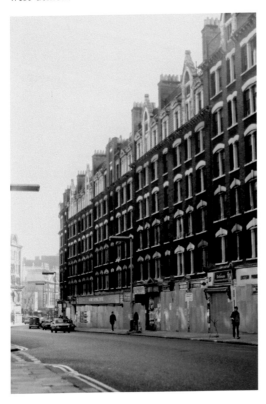

The buildings in Charing Cross Road, just before demolition, February 1981.

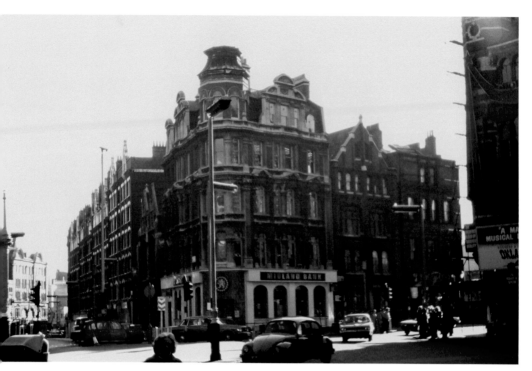

Cambridge Circus, seen at the same time in February 1981.

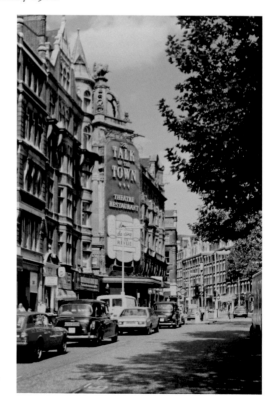

The Talk of the Town nightclub on Charing
Cross Road at the time of its closing in
August 1982. It later became Stringfellows and
is now the Hippodrome Casino.

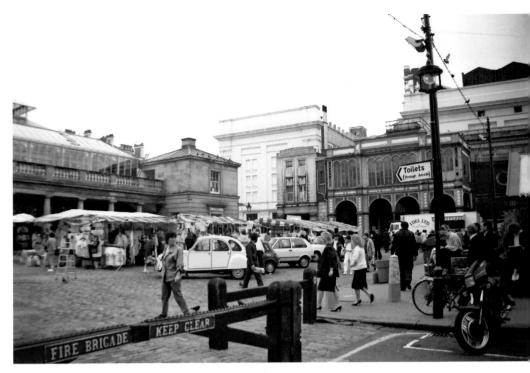

Covent Garden, June 1987.

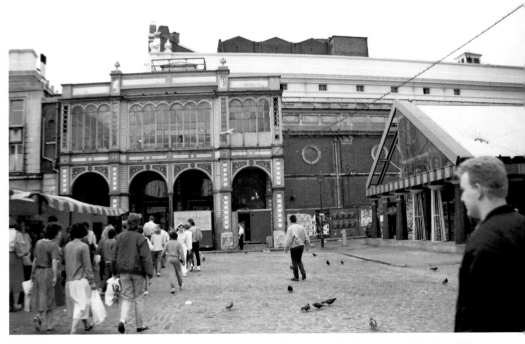

The old Floral Hall at Covent Garden in May 1987, before the redevelopment of the Royal Opera House. Some of the building survived and was moved to Borough Market, where it was used as a restaurant.

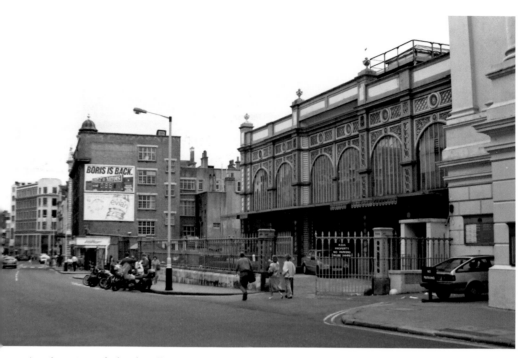

Another view of Floral Hall in May 1987, next to the Royal Opera House. Note the 'Boris is back' advert for the Stella Artois Tournament. Evian was very popular at the time.

Maxwell's Restaurant, Russell Street, May 1987. This was building slated for demolition in the Royal Opera House redevelopment, but the restaurant relocated nearby.

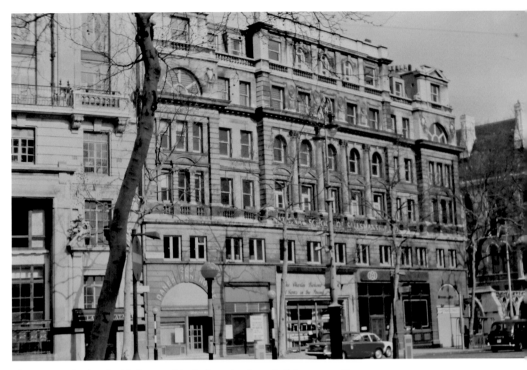

The National School of Salesmanship Ltd on the Strand, February 1981.

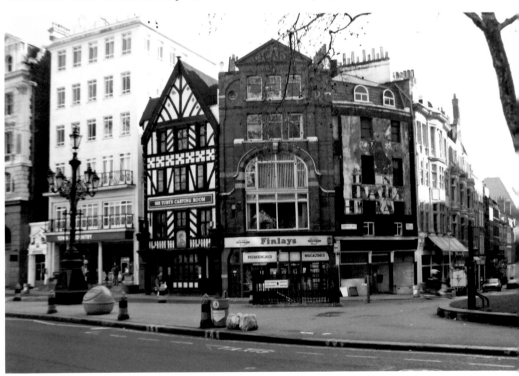

The Strand, January 1988.

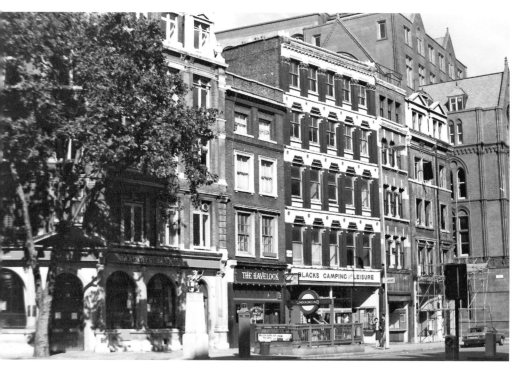

Holborn near Chancery Lane tube station, August 1980. Demolition is just about to start.

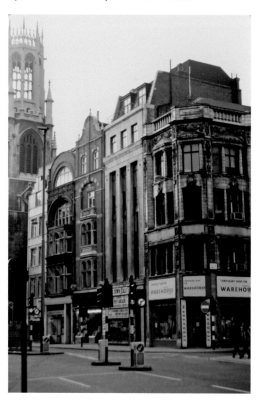

Fleet Street, February 1981. The building on the corner has been replaced.

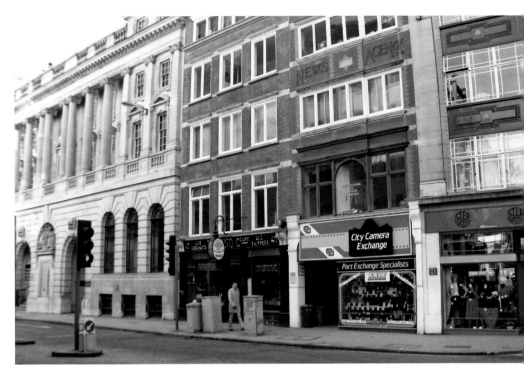

El Vino's bar, Fleet Street, January 1988.

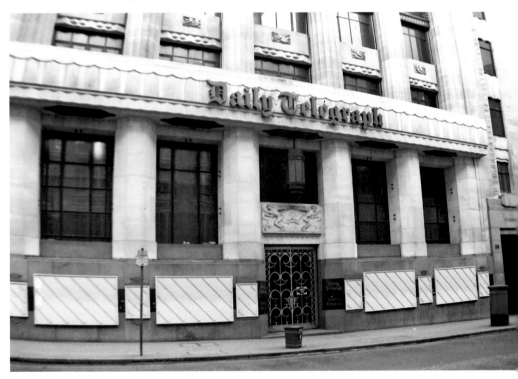

The *Daily Telegraph* building, Fleet Street, January 1988.

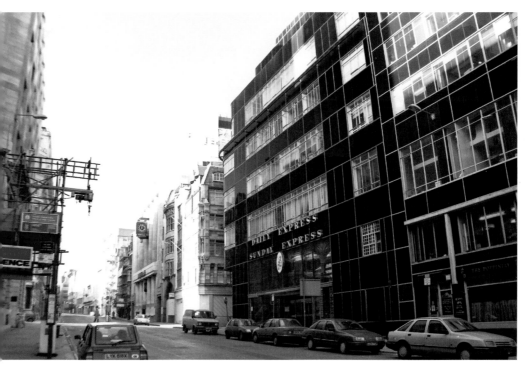

The *Daily Express* building, Fleet Street, January 1988.

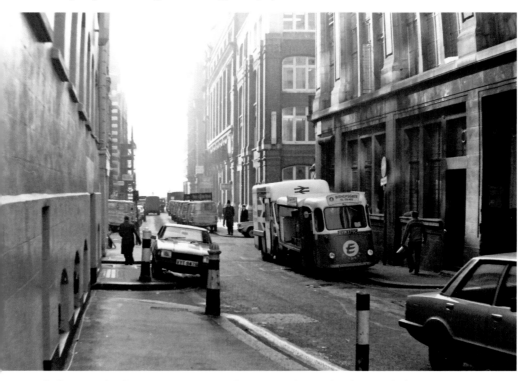

Milk float in Whitefriars Street, EC4, October 1980. Taken at the closure of *The Evening News*.

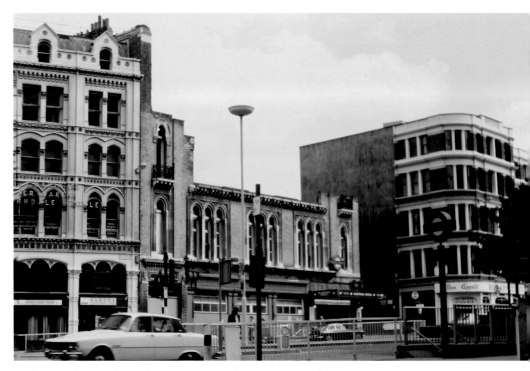

Bridge Chambers and Blackfriars station still showing wartime damage, June 1981.

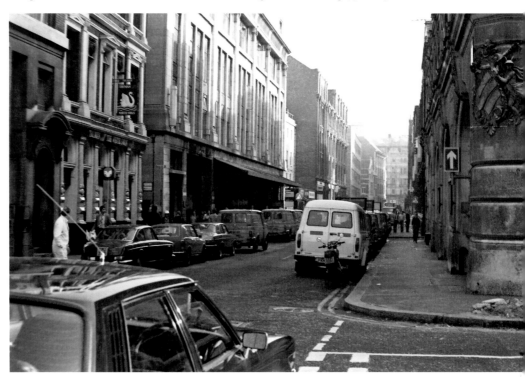

Tudor Street and Temple Avenue, EC4, October 1980. Taken at the closure of *The Evening News*.

St Bride's Passage, EC4, February 1981.

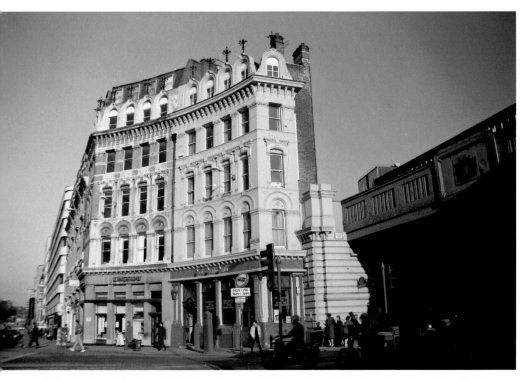

Old King Lud pub, Ludgate Hill, December 1987. The railway bridge has since been demolished.

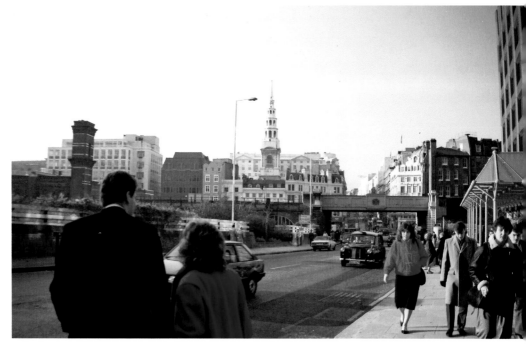

Ludgate Hill looking west, December 1987, before new railway development radically changed this area. The old Ludgate Hill station remains can be seen, along with Second World War bomb sites.

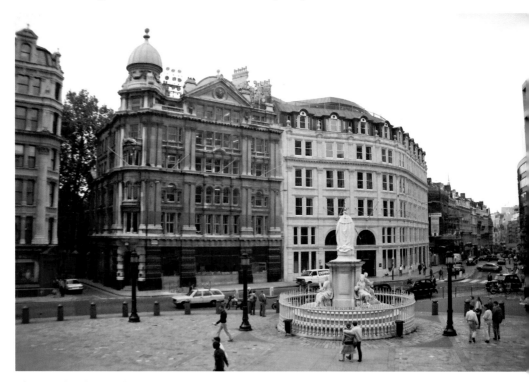

The top of Ludgate Hill, outside St Paul's Cathedral, June 1987.

Paternoster Square (the area behind St Paul's) before redevelopment, June 1987.

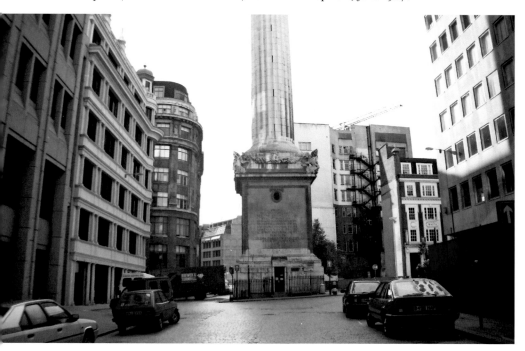

Monument and its surrounding area, August 1987. I had a relative who owned a sweet shop along here. There was said to be a graveyard at the back of the Monument station buildings. The station has been replaced and the buildings to the right have gone.

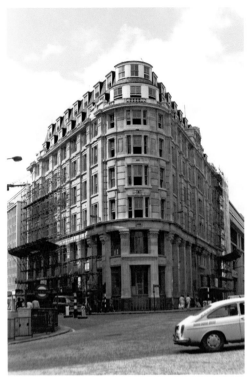

Demolition of Stafford House in King William Street, EC4, August 1980.

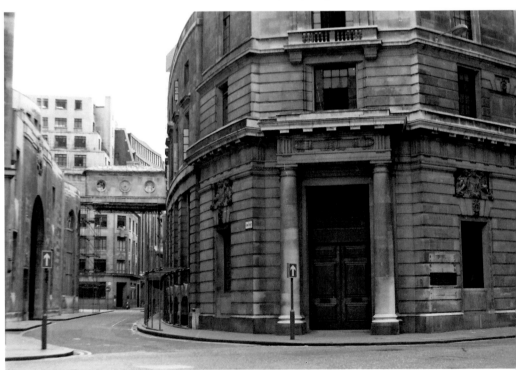

Lloyd's of London in Leadenhall Street, June 1980, just before it was demolished.

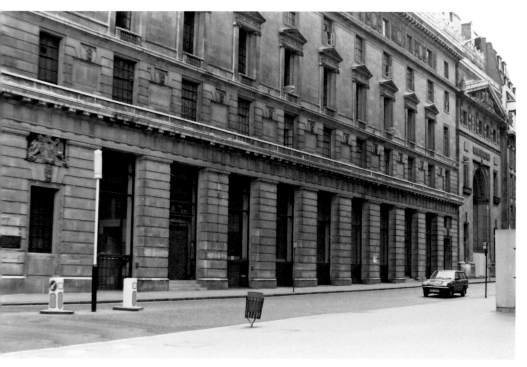

Another view of the old Lloyd's building, June 1980.

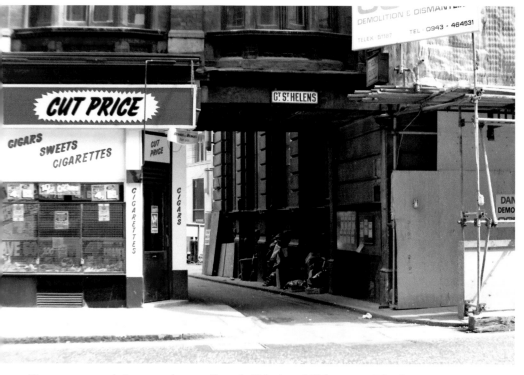

Cigars, sweets and cigarettes shop on Great St Helen's and Bishopsgate, EC2, June 1980.

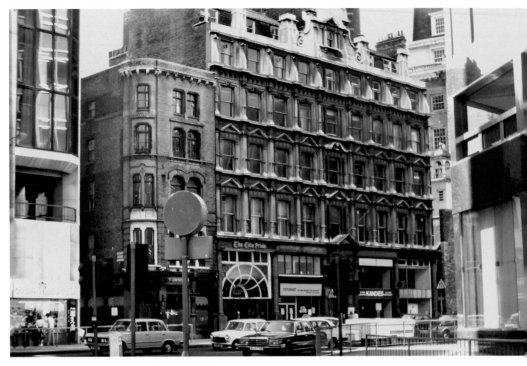

The City Pride pub, No. 80 Bishopsgate, EC2, August 1982.

Copthall Avenue looking towards London Wall, EC2, August 1987.

London Wall, July 1987. This area was one of the faces of modern London in the late 1960s, including the Highwalk system that was supposed to connect to Tower Hill. It was shown in films like *The Italian Job*, *Blow Up* and *The Long Good Friday*. Most of the area has since been rebuilt.

Another view of London Wall, July 1987, showing the Telephone Exchange at the junction with Wood Street.

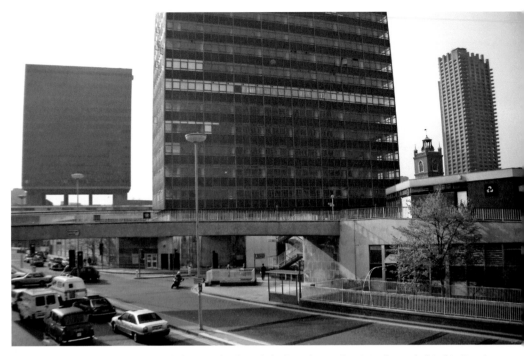

The base of Lee House (empty and about to be demolished) with St Giles Cripplegate behind it. Bastion House is to the left of the picture, April 1987.

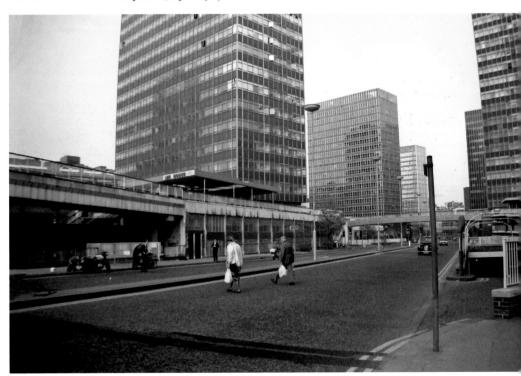

Looking east at Lee House, St Alphage House and Moor House, April 1987.

South side looking east at Moorgate, with Moor House on the left, April 1987.

Moorgate, March 1988.

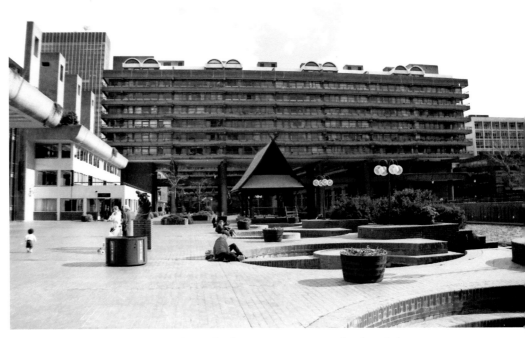

The Barbican, March 1988. The Barbican development was not completed until the 1970s.

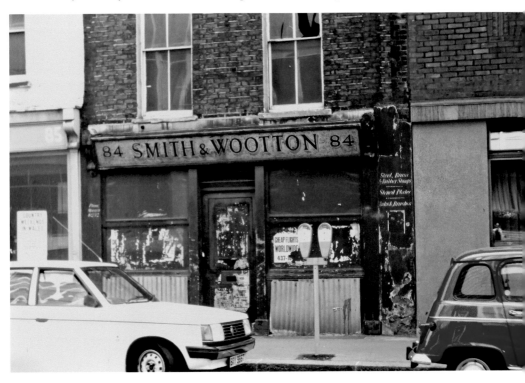

No. 84 Long Lane, EC1, August 1981.

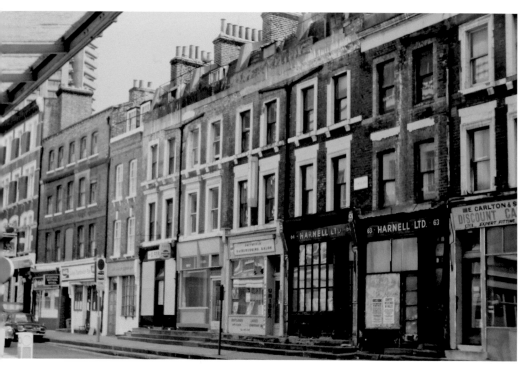

Another view of Long Lane, August 1981.

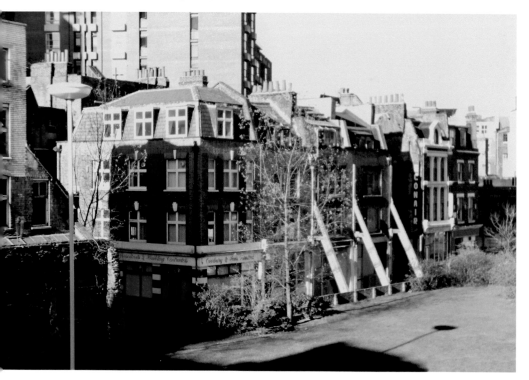

Albion Buildings, just north of Cross Keys Square, EC1, February 1981.

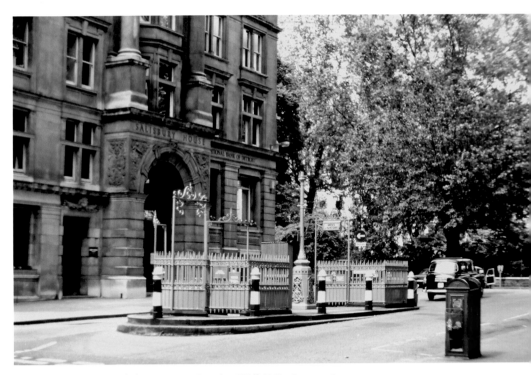

Public toilets next to Salisbury House, London Wall, EC2, June 1981.

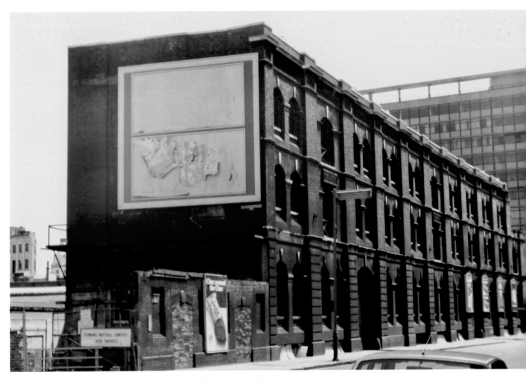

Farringdon Road, EC1, close to Farringdon station, August 1981.

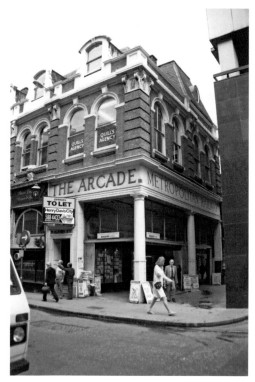

The Arcade, Old Broad Street, July 1987, which is undergoing redevelopment now.

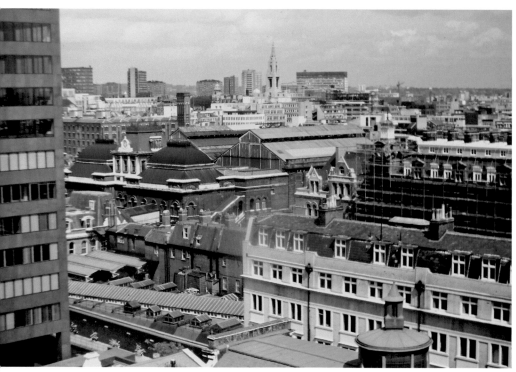

Broad Street station and Bishopsgate seen from Bishops' House, EC2, June 1981.

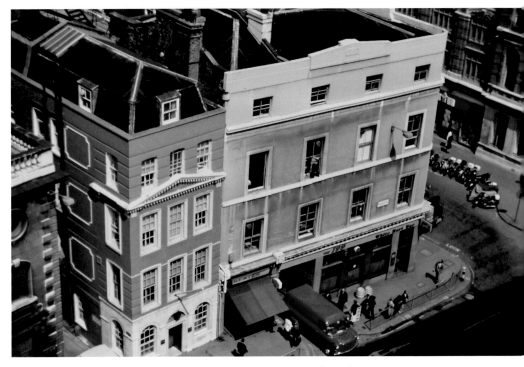

Bishopsgate seen from Bishops' House, June 1981. Note the window cleaner!

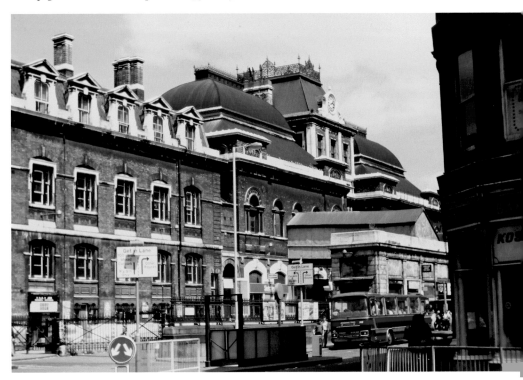

Broad Street station, Liverpool Street, June 1981.

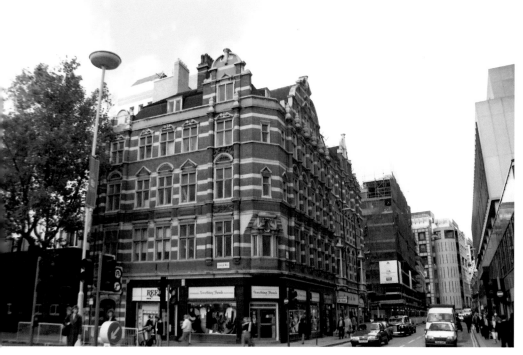

Old Broad Street, EC2, October 1989.

Tower Hill, outside the old station entrance, April 1987.

Docklands

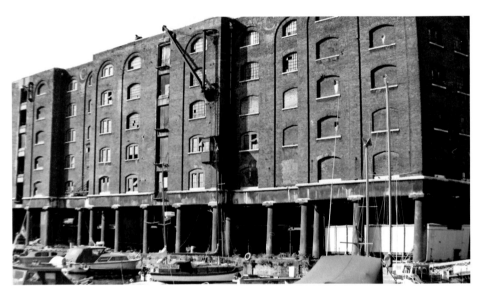

St Katherine's Dock warehouses, E1, August 1980.

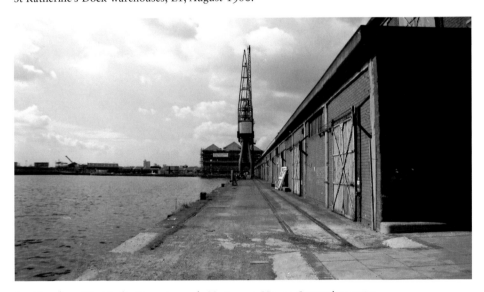

Looking from West India Quay towards Hertsmere House, September 1987.

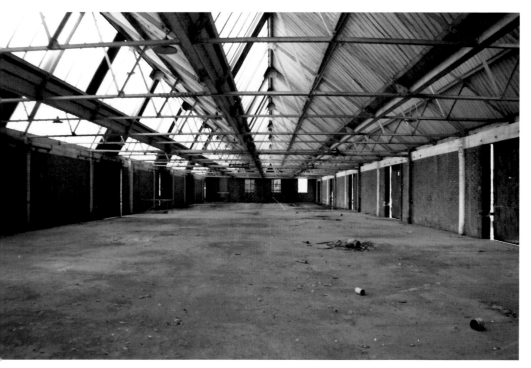

Interior of West India Quay warehouse, September 1987.

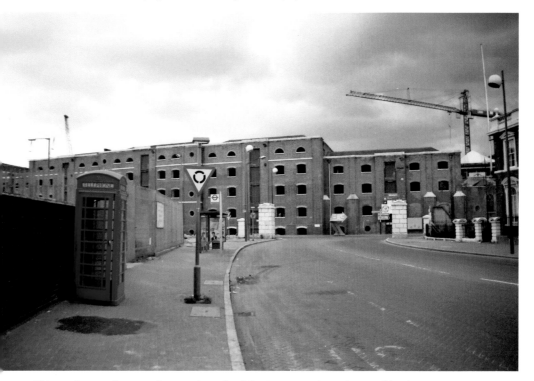

Old warehouses that now house a branch of the Museum of London Docklands, June 1987.

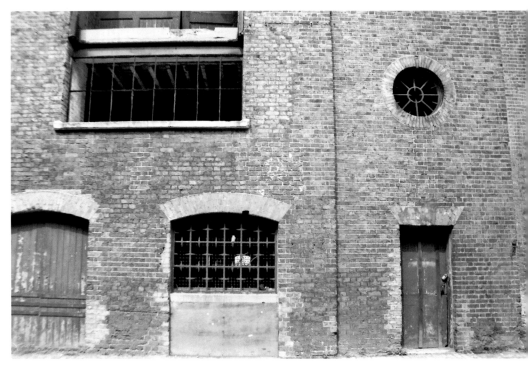

Close-up of Port East warehouses, West India Quay, now Museum of London Docklands, May 1988.

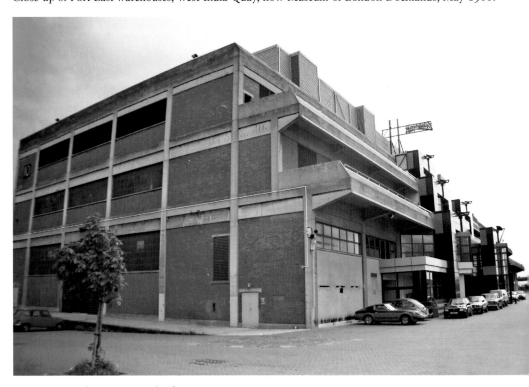

Limehouse Studios, Canary Wharf, June 1987.

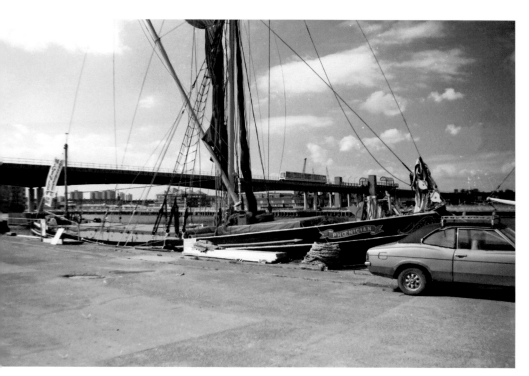

View from Heron Quays, July 1987.

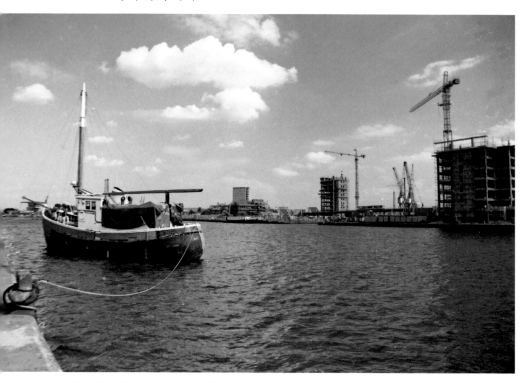

Another view from Heron Quays on the same date.

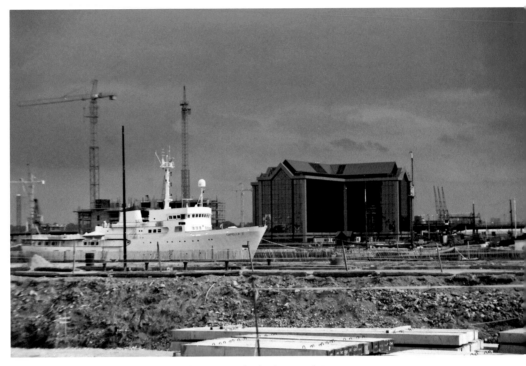

Capella C expedition yacht with South Quay in the background, June 1987.

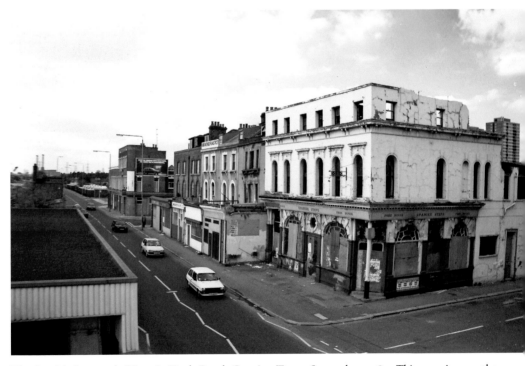

The Spanish Steps pub, Victoria Dock Road, Canning Town, September 1987. This area is now the home to the Excel Centre.

North and East

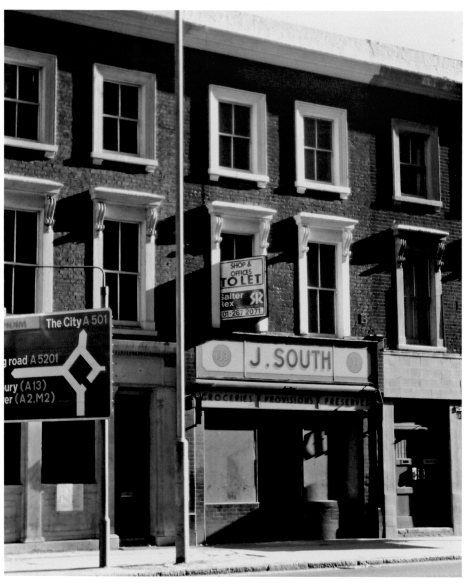

Shop to let on City Road, EC1, February 1981.

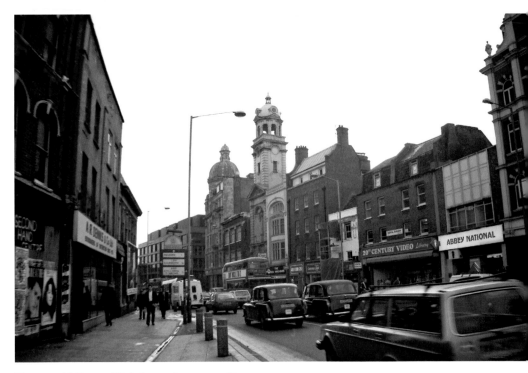

The top of Islington High Street, January 1988.

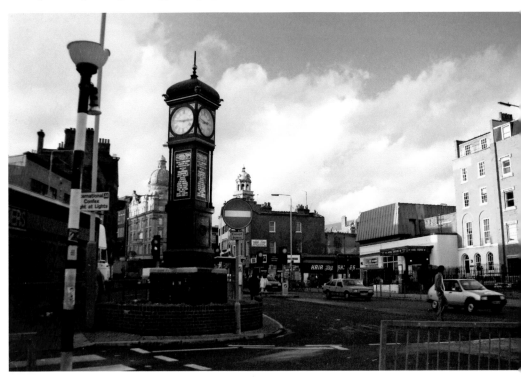

Near the entrance of Angel tube station, January 1988.

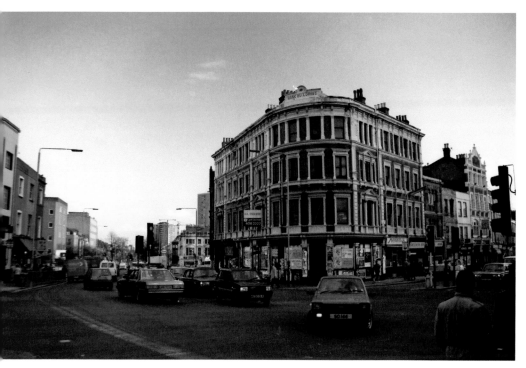

Another view of the area around Angel, soon to be redeveloped, January 1988.

Upper Street, N1, January 1988.

Street posters near Angel, January 1988.

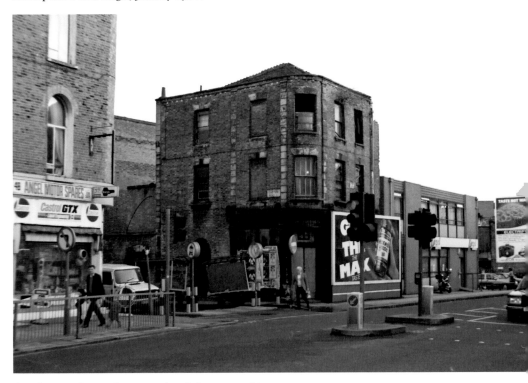

Angel Motor Spares shop, near Angel, January 1988.

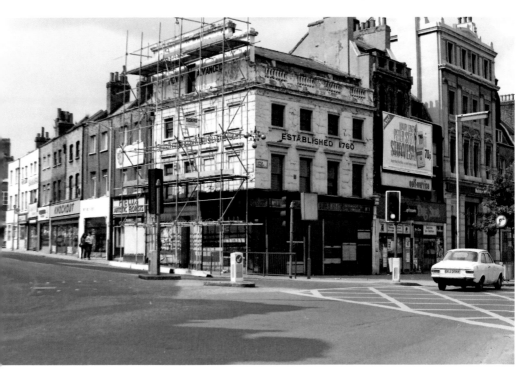

The corner of Liverpool Road, N1, June 1980.

Stoke Newington Road, N16, June 1983.

The old Stoke Newington police station on the High Street, May 1987.

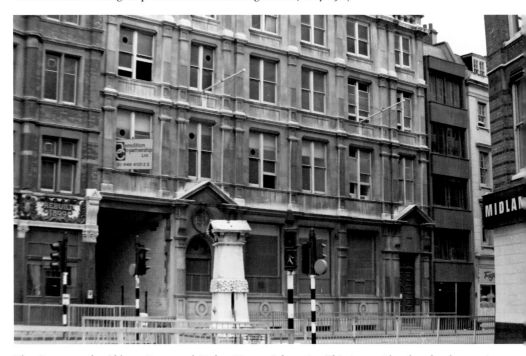

The George at the Aldgate Pump and Finlay House, July 1980. This is considered to be the starting point of London's East End. This pump was notorious for killing a lot of people with cholera in the 1860s. The pump is still there, but virtually every other building has been replaced.

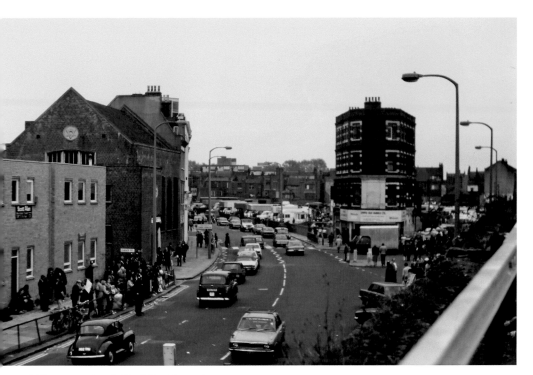

Bishopsgate Goods Yard E1, November 1981.

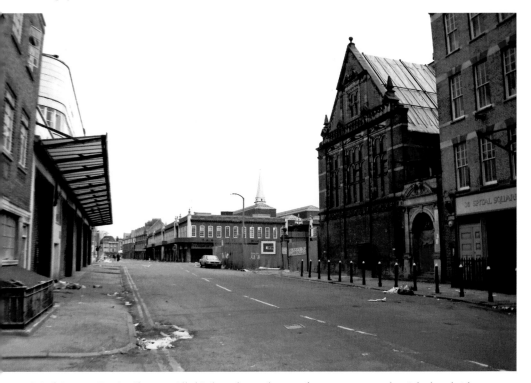

Spital Square, E1, April 1988. All this has changed, apart from an area on the right-hand side.

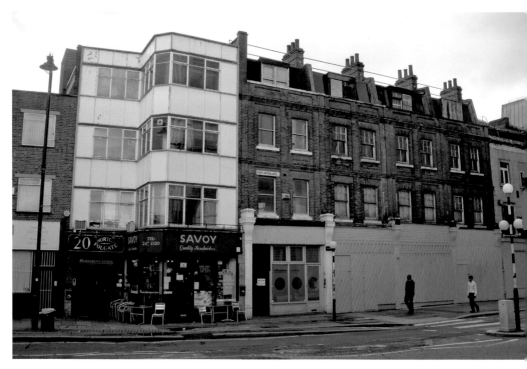

Blossom Street, E1, before redevelopment, June 2010. Seen from Norton Folgate/Bishopsgate.

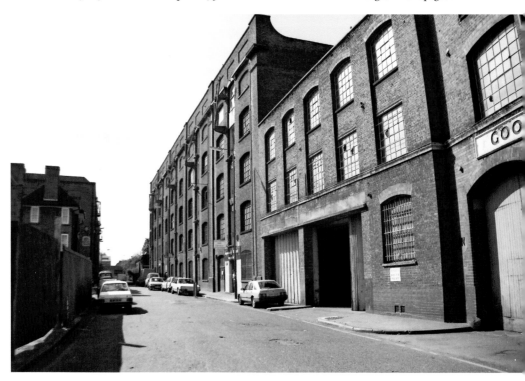

Warehouses in Back Church Lane, E1, September 1987.

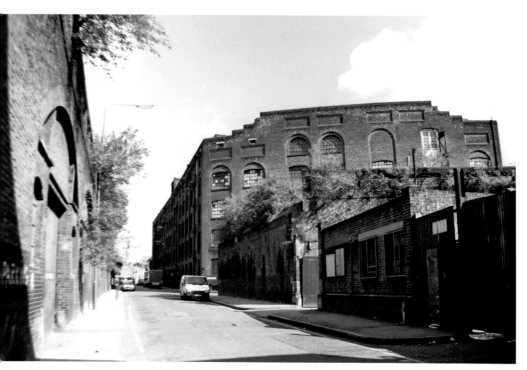

Another view of Back Church Lane, E1, September 1987.

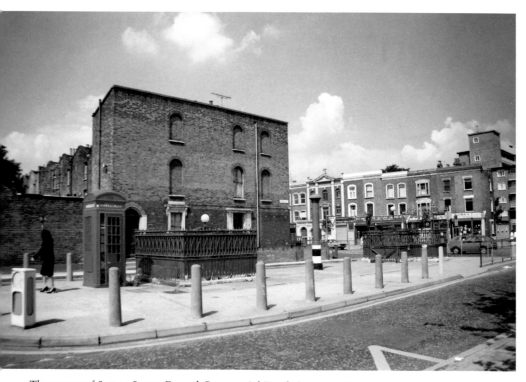

The corner of Sutton Street, E1 and Commercial Road, August 1987.

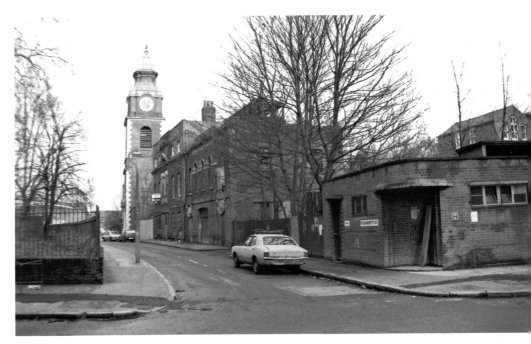

Scandrett Street, E1, Wapping, January 1988. This is where Harold Shand's car stops when his pub is blown up in *The Long Good Friday*. Ebenezer Scrooge's house is also located here in the film *A Christmas Carol* (1951).

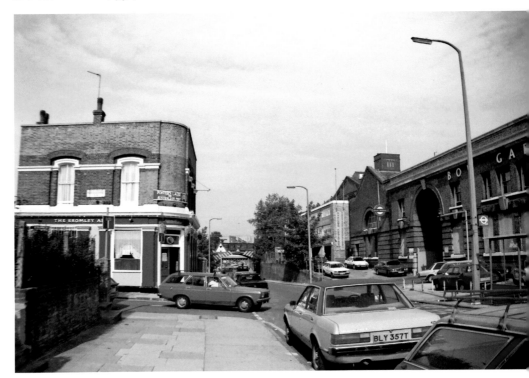

Bow Bus Garage, Fairfield Road, E3, September 1987. The pub opposite has since closed.

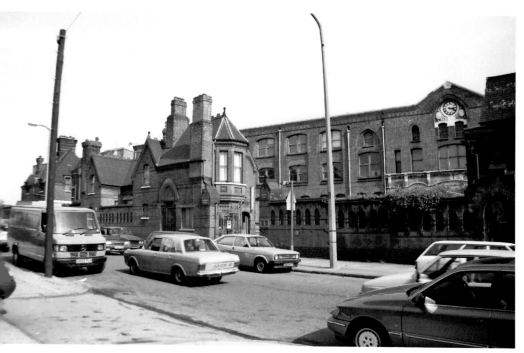

The Bryant & May match factory in Fairfield Road, E3, September 1987. This was the site of the matchgirls' strike in 1888. It is now the Bow Quarter housing.

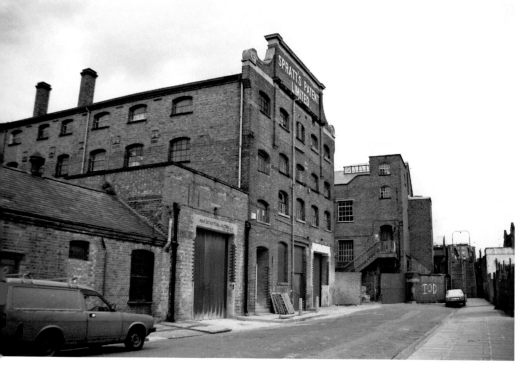

Spratt's Patent dog biscuit factory, June 1987, now flats in Fawe Street, Limehouse Cut.

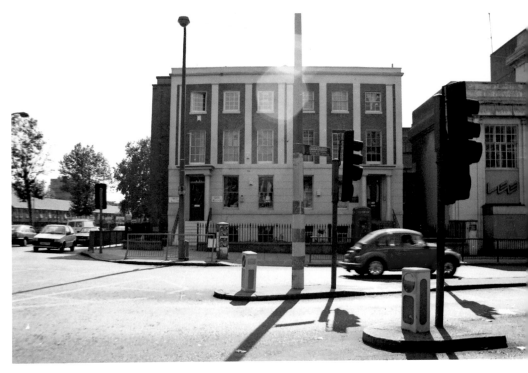

Lower Clapton Road, E5, September 1987.

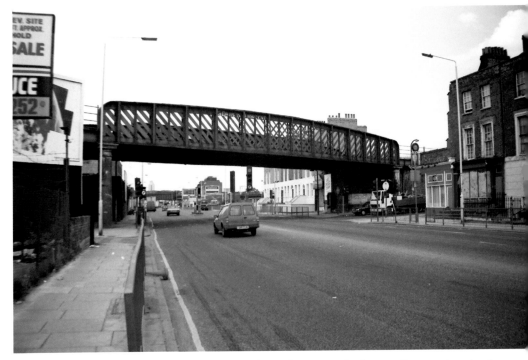

A long-disused railway bridge over Commercial Road, E14, with Stepney East station in the background, August 1987.

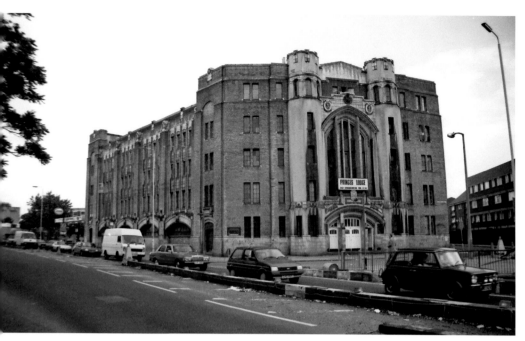

This Grade II listed building on Commercial Road, E14, seen in August 1987, was originally known as the Empire Memorial Sailors' Hostel. Its foundation stone was laid on 13 March 1923 and it later became Prince's Lodge, an infamous homeless hostel mentioned by John Pilger. It is now known as The Mission and contains fifty flats.

Mill Road, E16, February 1988.

The old London & Blackwall railway station at Three Colt Street, E14, August 1987. I believe it was called Limehouse and shut in 1926.

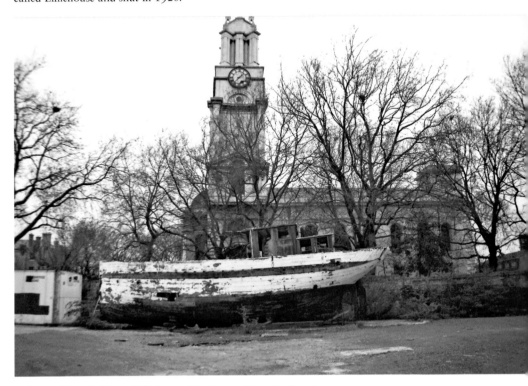

St Anne's Church, Three Colt Street, Limehouse, E14, April 1987.

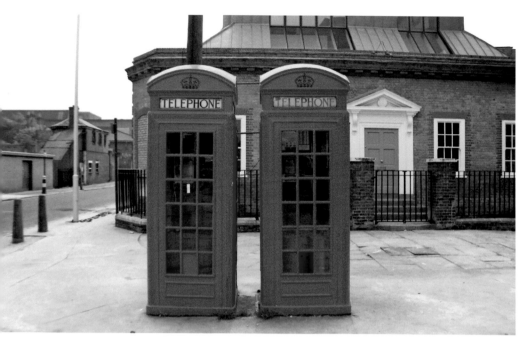

Branch Road and The Highway, Horseferry Road, E14, May 1988. This scene appears different today due to the building of the Limehouse Link Tunnel under the Limehouse Basin. The small building behind the telephone boxes was a Seaman's Mission.

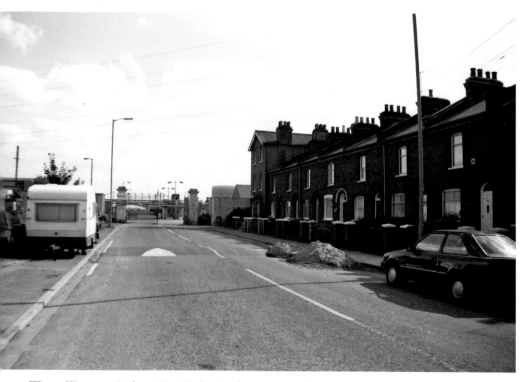

Winsor Way, near Beckton Gas Works, Sunday 27 September 1987.

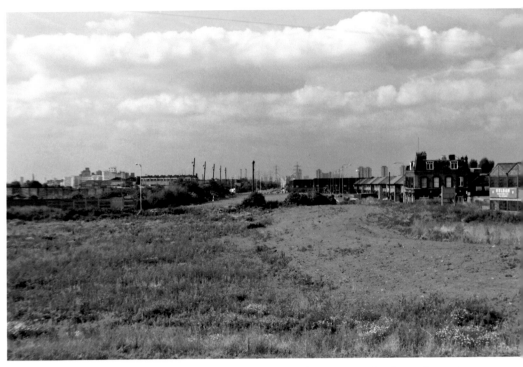

Looking towards the old Ferndale Pub (now housing) near Beckton Gas Works, September 1987.

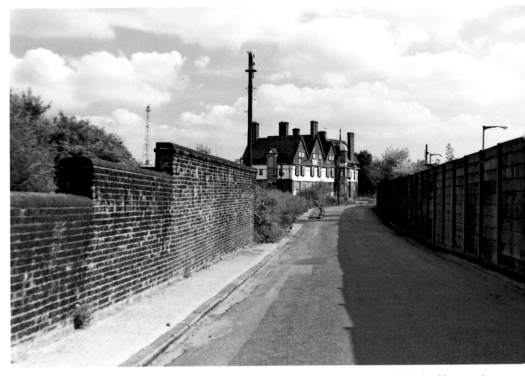

Gallions Reach Hotel, near Beckton Gas Works, September 1987. This is surrounded by buildings today.

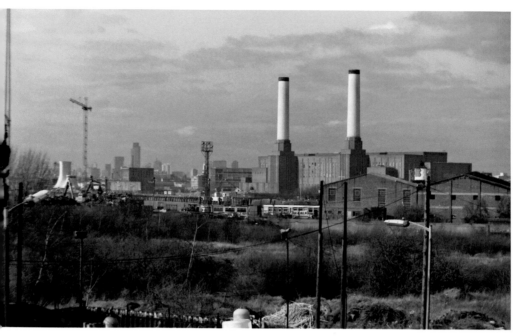

Blackwall Power Station, also known as Brunswick Wharf Power Station, seen from Silvertown Way in February 1988. The power station replaced a railway and then made way for the Docklands Light Railway, which opened in July 1987.

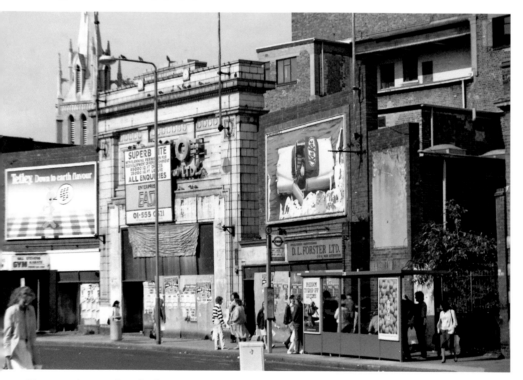

Tramway Avenue, Stratford, E15, August 1987.

Stratford High Street, August 1987. The old, boarded-up Stratford Market station is now the new DLR station. The Pantry Café still exists.

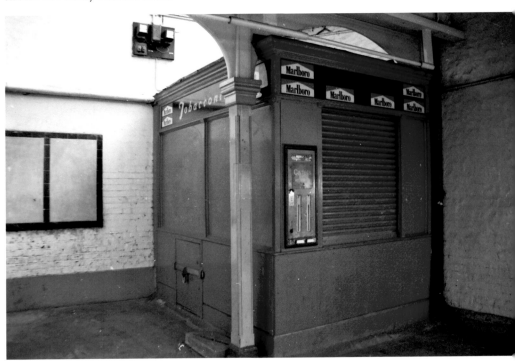

The Cadet cigarette machine in Leyton station had a sign that said: 'Free gifts'. Someone had written in felt pen under that: 'Lung Cancer'! July 1987.

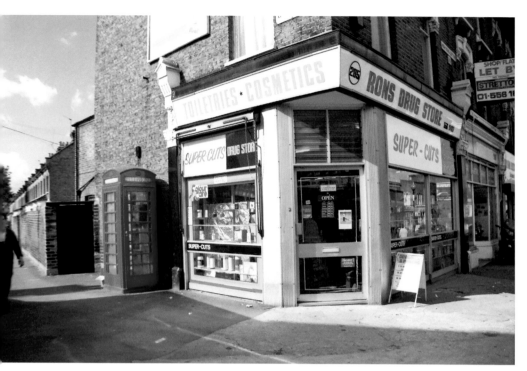

Rons Drug Store, High Road, Leyton, E10, September 1987.

The Working Men's Club and Institute Union (CIU), High Road, Leyton, September 1987.

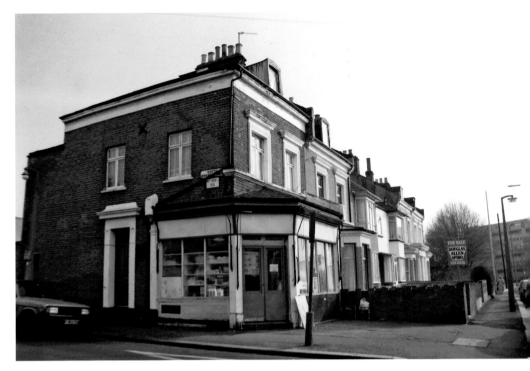

Corner shop on South Birkbeck Road, Leyton, January 1989.

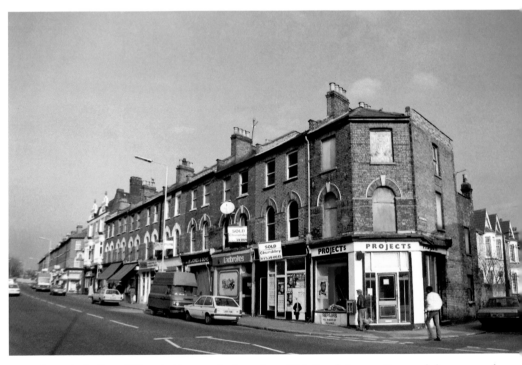

More shops, including a TV and video repair shop along High Road, Leyton, E15, and the corner of Leslie Road, E11, January 1989.

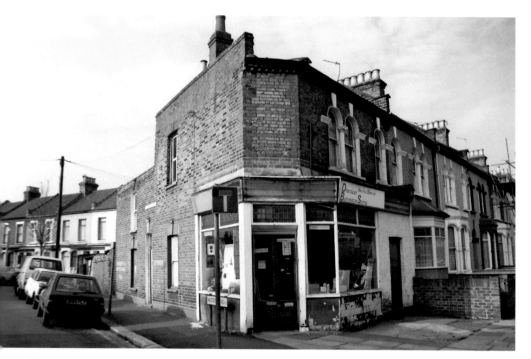

'Heating supplies and discount bathroom suites', Westdown Road and High Road, Leyton, E15, January 1989.

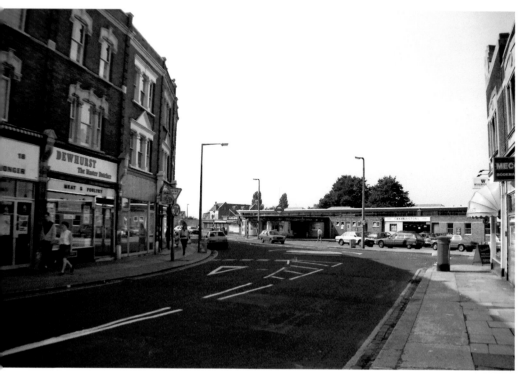

Leytonstone Underground station viewed from Church Lane, E11, September 1987.

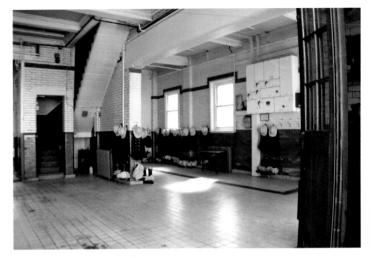

Leytonstone High Road fire station interior, September 1987.

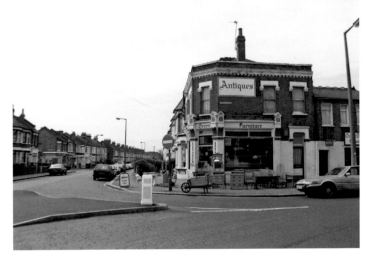

Second-hand furniture shop, Grove Green Road, E11, March 1989. This shop, and the next one, are both now housing.

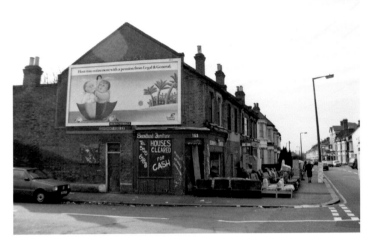

Grove Green Antiques on Grove Green Road, E11, March 1989.

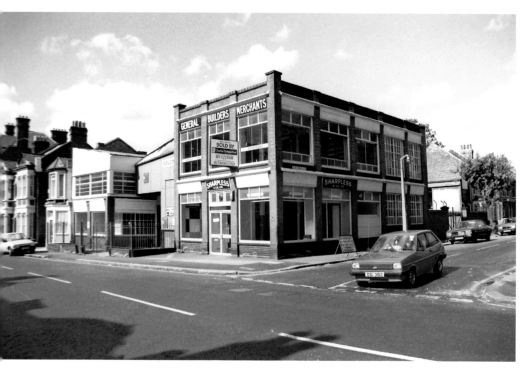

'General Builders Merchants', Grove Green Road, E11, September 1987.

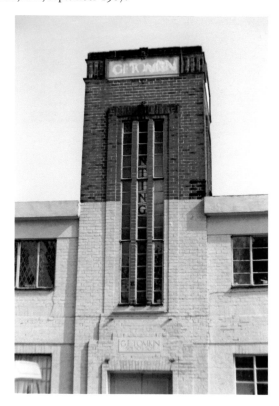

G. F. Tomkin printing works before
demolition for the M11 link road (A12),
Grove Green Road Leytonstone, E11, Sunday
24 May 1987

South and West

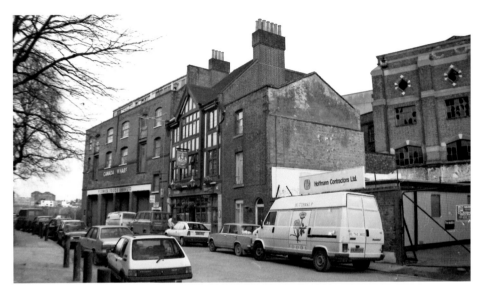

Canada Wharf and the Blacksmith's Arms, Rotherhithe Street, SE16, February 1988.

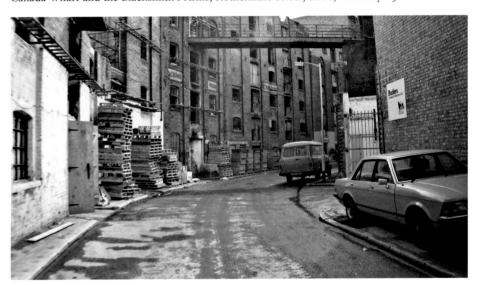

Warehouses being converted on Shad Thames, Bermondsey, April 1987.

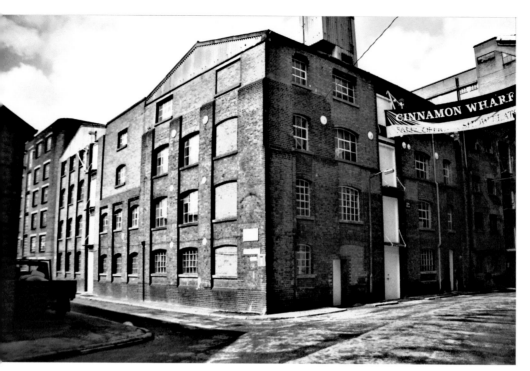

More warehouses being converted in the Bermondsey area, April 1987.

The Potters Field area, Tooley Street, near Tower Bridge, SE1, in April 1987, prior to the building of City Hall.

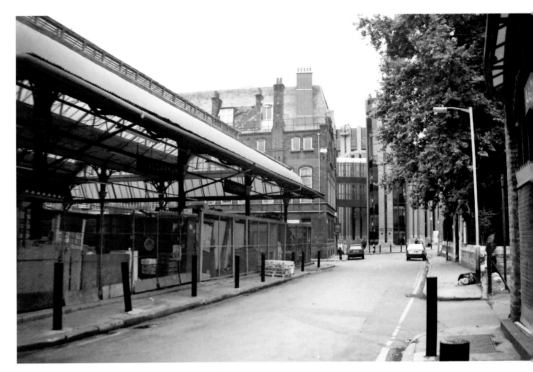

Borough Market, Cathedral Street, SE1, July 1987.

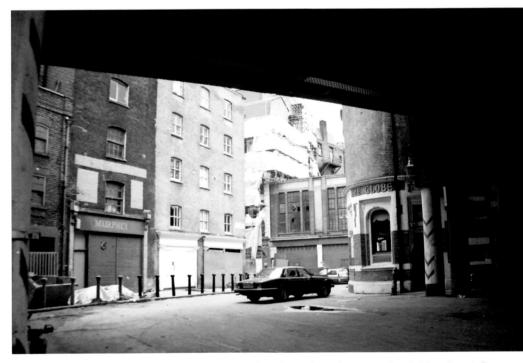

The Globe, Borough Market, SE1, July 1987. The flat above the pub was used as Bridget Jones' flat. Another railway viaduct has been built since this image was taken.

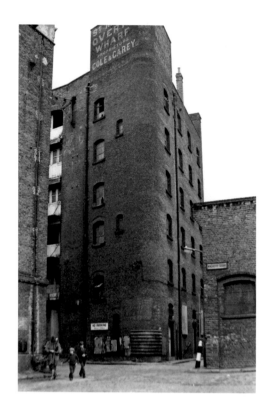

St Mary Overy's Wharf and Winchester Square,
SE1, October 1980.

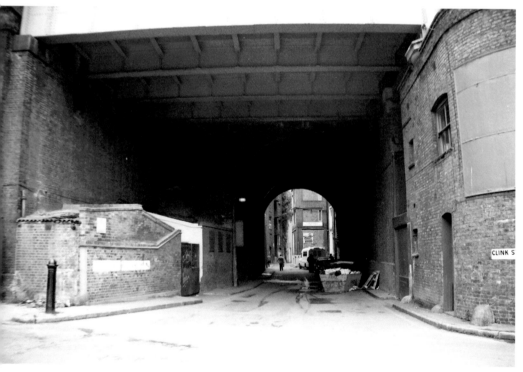

Clink Street, SE1, before the (tourist) prison was there. July 1987.

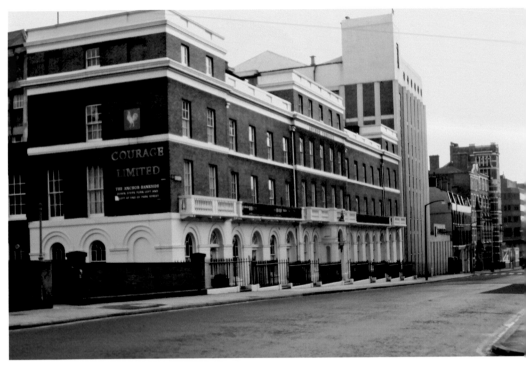

Courage's South Bank Brewery, Southwark Bridge Road, SE1, November 1980.

Upper Ground and Barge House Street, SE1, January 1981. This area was used in the film *The Elephant Man* and in an episode of TV's *On the Buses*.

The OXO Tower building (Dewhurst's), Barge House Street, SE1, July 1987.

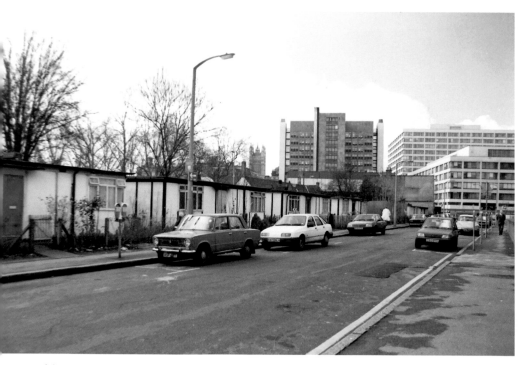

Prefabs in Royal Street, SE1, with St Thomas's Hospital in the background, January 1989. It seems the land hasn't been built on and it is now a city farm.

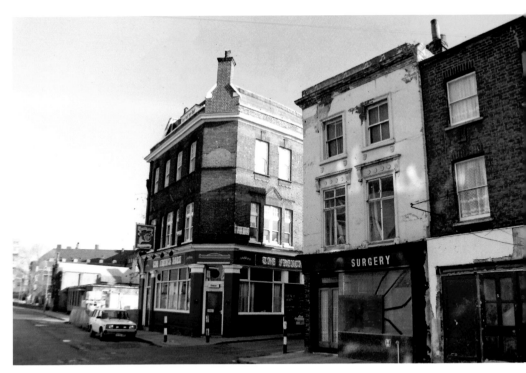

Lambeth Walk, SE11, January 1989.

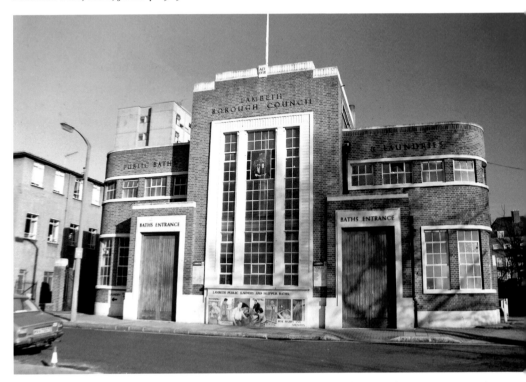

Lambeth Public Baths and Laundry on Lambeth Walk, January 1989. It has since become a GP practice.

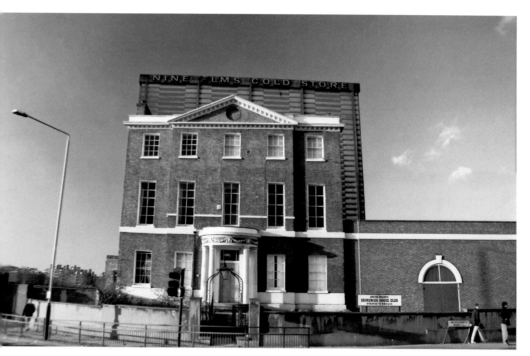

British Rail's Brunswick House Club with Nine Elms Cold Store behind, Wandsworth Road, SW8, January 1989. It is now a restaurant.

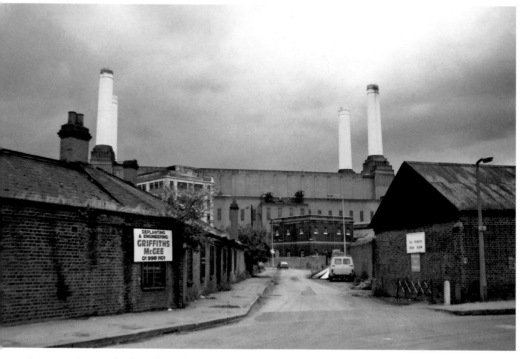

Battersea Power Station, disused and awaiting redevelopment in July 1987. Derelict for years, the redeveloped site was not open to the public until 2022.

Marco Polo House, beside Battersea Park, July 1987. It was named after the explorer, who lived in the area, and was built in 1987/88. The site actually comprised two separate buildings. The postmodern structure was originally the headquarters of British Satellite Broadcasting (BSB) and the building on the right housed the *Observer* newspaper. It was demolished in 2014 and replaced by flats as part of the Battersea Power Station redevelopment.

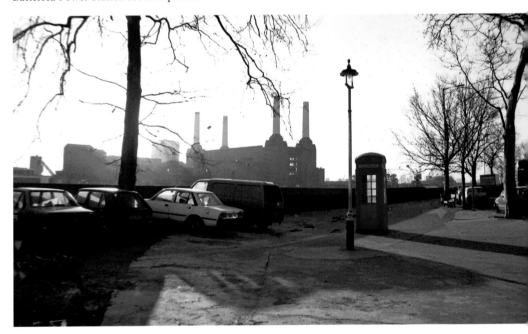

Battersea Power Station, seen across the river from Grosvenor Road, Chelsea, SW1, January 1989.

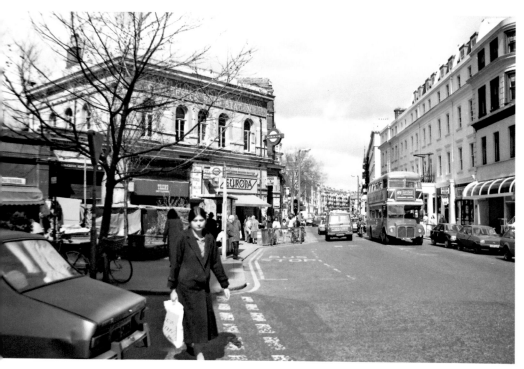

Gloucester Road, SW7, near the Underground station, April 1987.

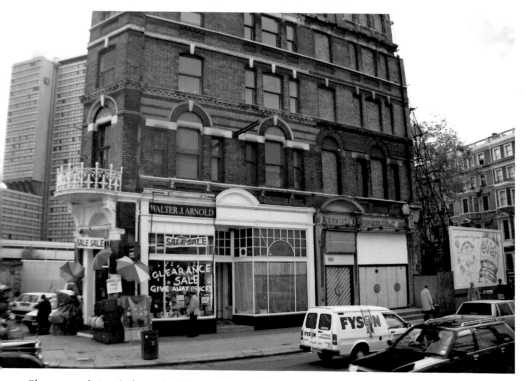

Clearance sale just before rebuilding work started on Gloucester Road station, May 1987.

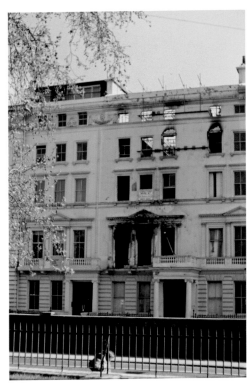

The Iranian Embassy, Prince's Gate, SW7, in April 1981, showing the aftermath of the siege and the SAS visit the year prior.

The perimeter fence of the old White City Dog Stadium, July 1987. It was reused as a BBC site, but they have since moved on.

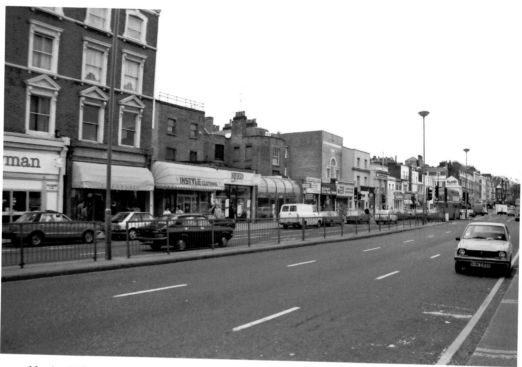

Notting Hill Gate, May 1987.

Edgware Road, W2, October 1989.

Pubs, Shops and Cafés

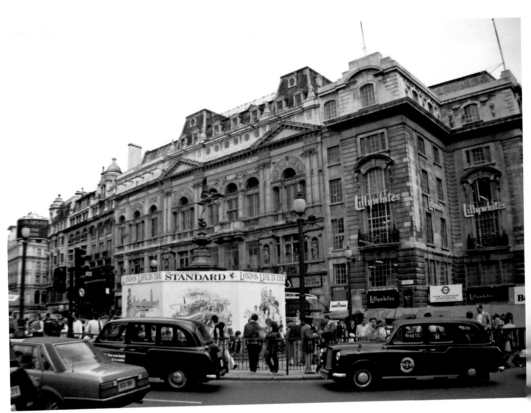

Lillywhite's sports shop, Piccadilly Circus, May 1987, before redevelopment.

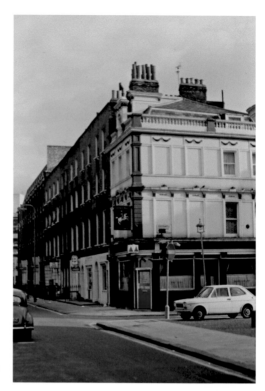

The George & Dragon pub at the junction of
Cleveland Street and Greenwell Street, Fitzrovia,
W1, March 1981.

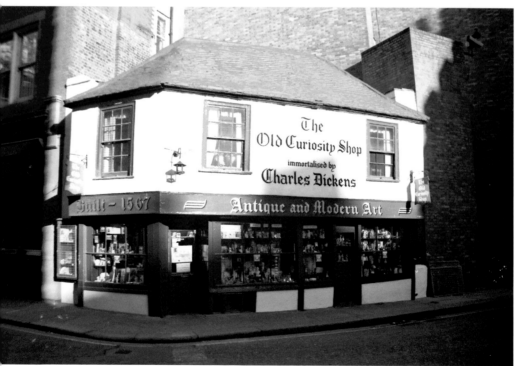

The Old Curiosity Shop, WC2, when it was an antique shop, January 1988.

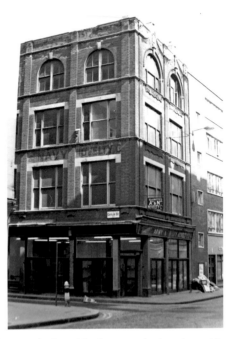

Above left: The Green Man pub was at the southern end of Bucklersbury, at the junction with Pancras Lane, EC4, February 1982. The area has since been redeveloped.

Above right: The Army & Navy Novelty Co., Houndsditch, EC3, at the junction of Cutler Street, August 1980.

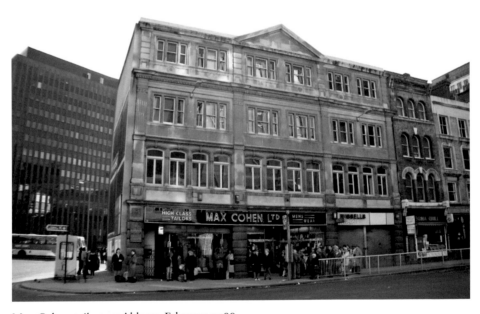

Max Cohen, tailors, at Aldgate, February 1988.

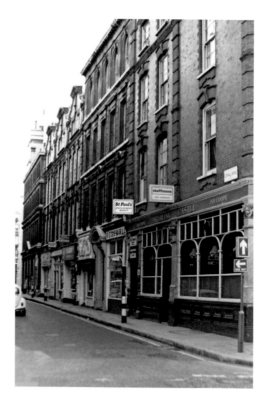

The Stirling Castle pub, Copthall Avenue, EC2, September 1980.

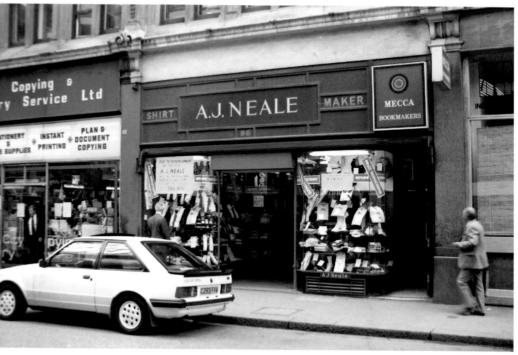

A. J. Neale was a city shirtmaker in Old Broad Street, July 1987. It is now part of the Dennys of Soho company.

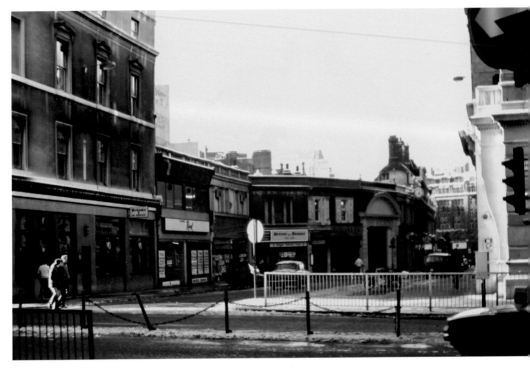

Parade of shops in Liverpool Street, EC2, in snowy December 1981.

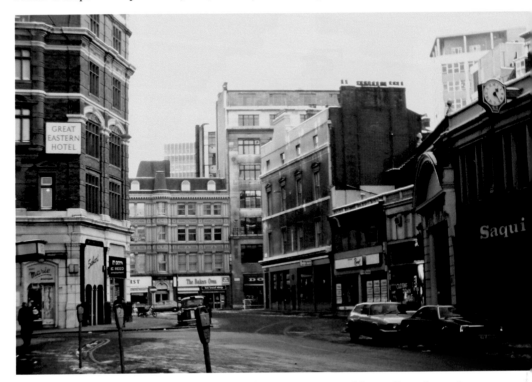

The Great Eastern Hotel before refurbishment and renaming, Liverpool Street, December 1981.

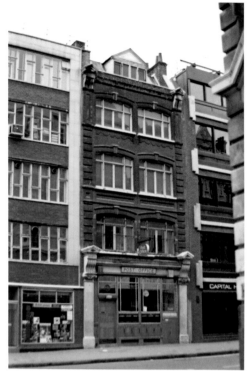

A typical post office at this time. City Road, EC1, July 1980.

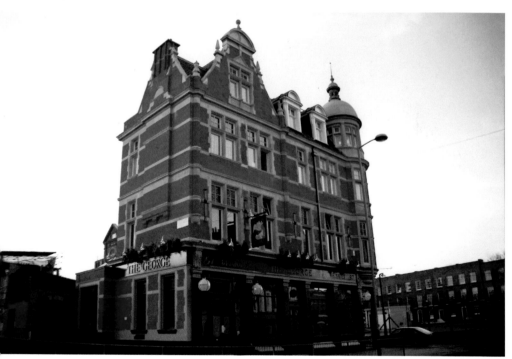

The George pub near Angel station, Liverpool Road, N1, January 1988. It has since been renamed 'The Angelic'.

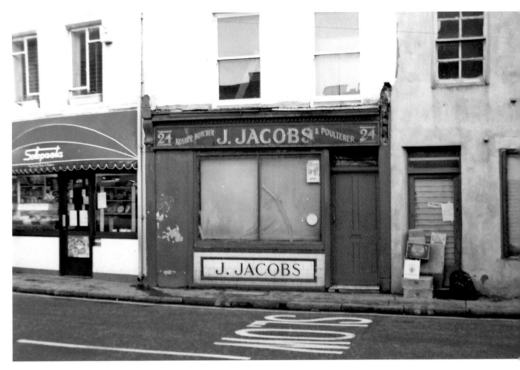

Old butcher's shop frontage, near Angel, N1, January 1988.

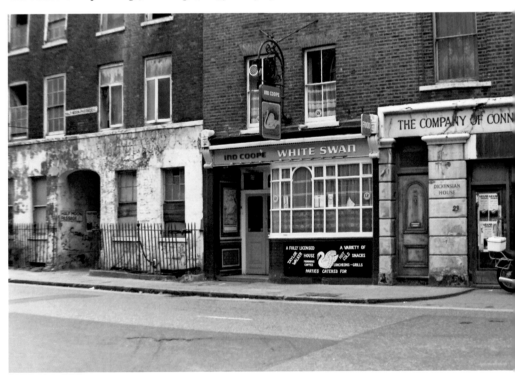

The White Swan pub, Half Moon Passage, E1, June 1980.

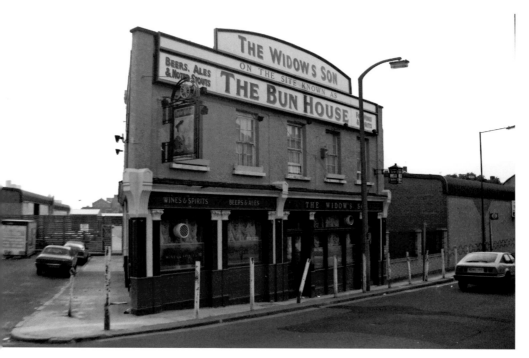

The Widow's Son pub, Devons Road, E3, September 1987. It was also known as The Bun House because of a tradition of storing hot cross buns in a net in the ceiling after a widow's son was lost at sea during the Napoleonic Wars. The pub later closed and plans were put forward to convert it to housing, but it has since reopened.

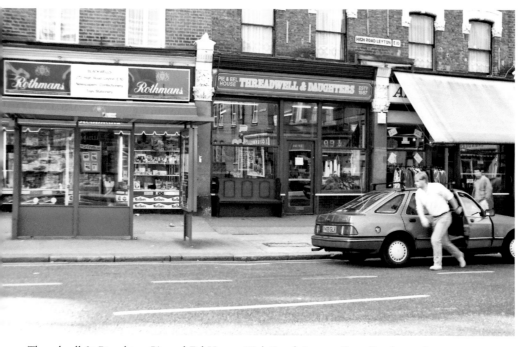

Threadwell & Daughters Pie and Eel House, High Road, Leyton, E10, October 1987.

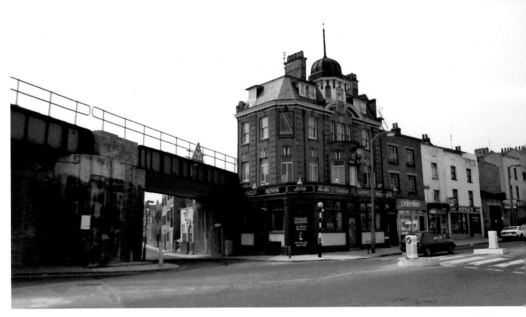

Charlie Browns pub, Limehouse, May 1988. It was later demolished due to the construction of the Limehouse Link Tunnel.

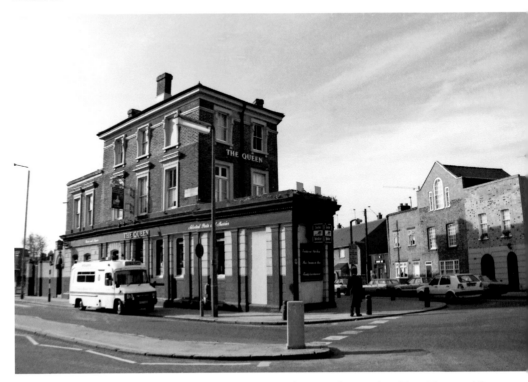

The Queen Pub, Manchester Road, E14, February 1988. It has since been replaced by a Tesco and flats.

Three Compasses pub, Rotherhithe Street, SE16, February 1988. It is now a Pizza Lounge restaurant.

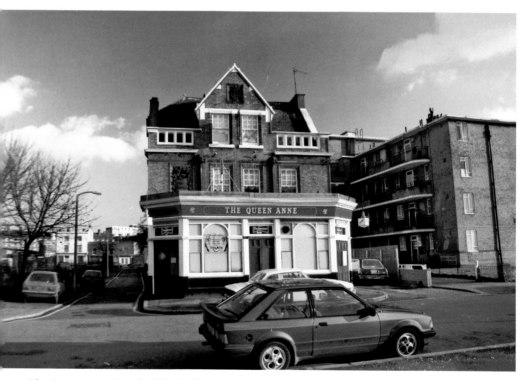

The Queen Anne, Vauxhall Walk, SE11, January 1989. It is now the Tea House Theatre Cafe.

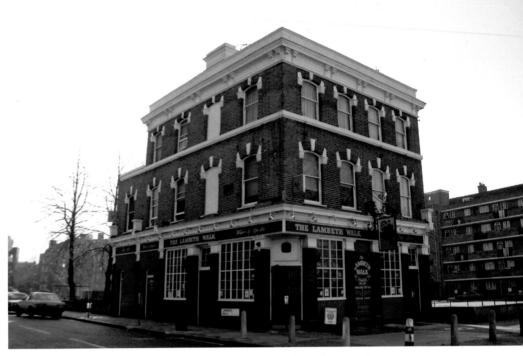

The Lambeth Walk pub on the corner of Lambeth Walk and Lambeth Road, January 1989.

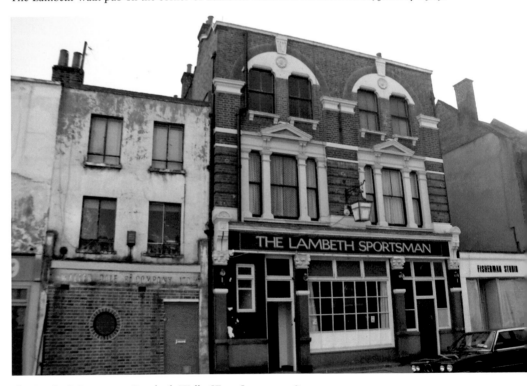

The Lambeth Sportsman, Lambeth Walk, SE11, January 1989.

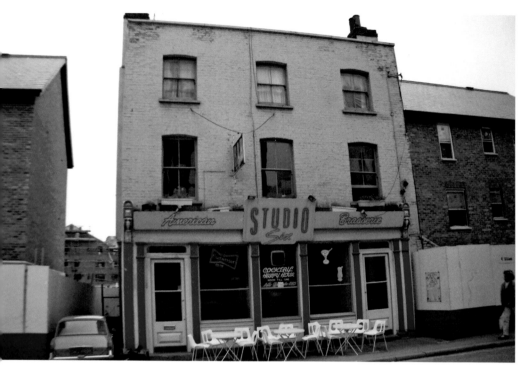

Studio Six Bar, Upper Ground, SE1, July 1987.

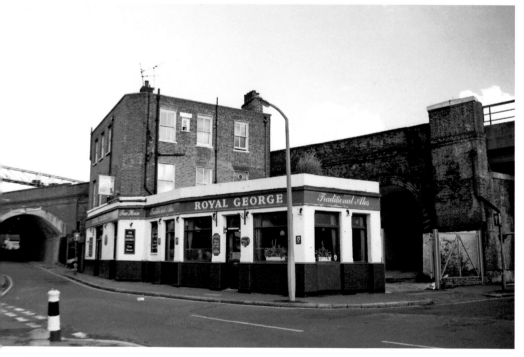

The Royal George pub, Carlisle Lane, SE1, January 1989. This fell victim to a new Eurostar railway viaduct.

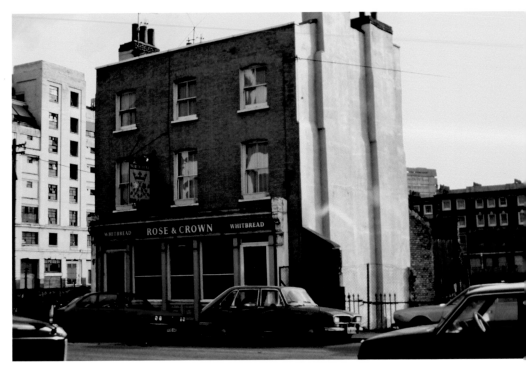

Rose & Crown, Upper Ground, SE1, January 1981.

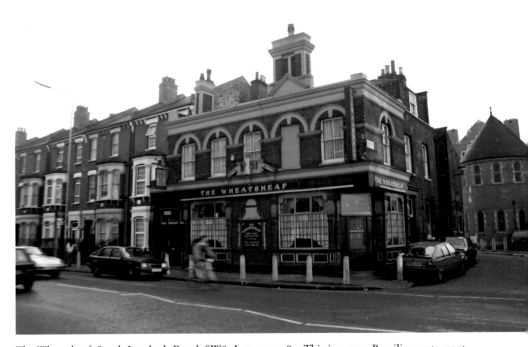

The Wheatsheaf, South Lambeth Road, SW8, January 1989. This is now a Brazilian restaurant.

Getting About

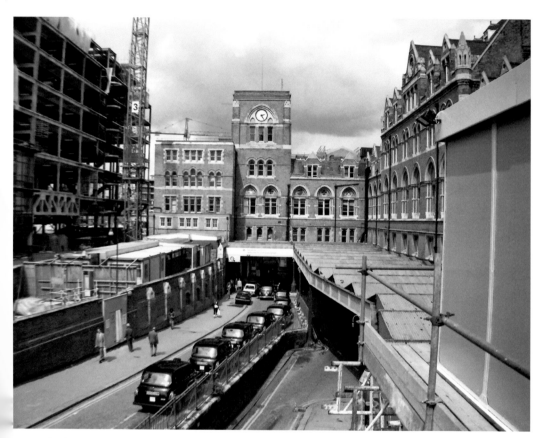

Black cabs line up outside Liverpool Street station, May 1987.

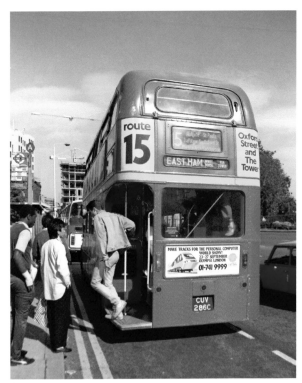

A passenger alights from a Routemaster bus outside the Tower of London, August 1987.

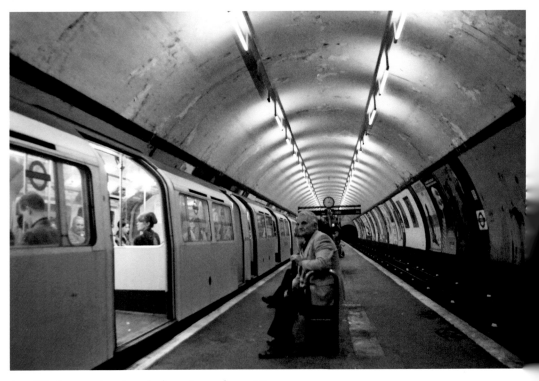

Angel Underground station platform, September 1988.

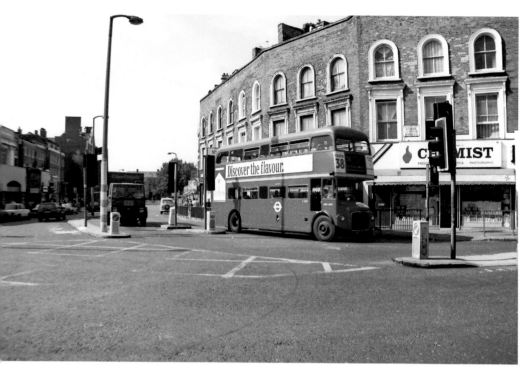

A Routemaster bus on Route 38, Lower Clapton Road, E5, September 1987.

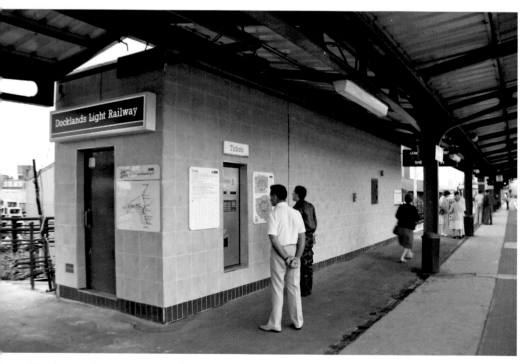

Monday 31 August 1987 saw the opening of the Docklands Light Railway to the public. Passengers inspect the ticket machine at Stratford station.

Island Gardens station, the other end of the line on the Docklands Light Railway, on the opening day, 31 August 1987.

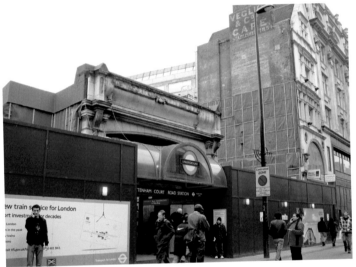

Rebuilding Tottenham Court Road tube station in March 2010 for Crossrail (to be renamed the Elizabeth Line). The Veglio Café ghost sign disappeared with the rebuilding.

I wonder what Rita, the lovely meter attendant, is smiling about in Bow Street, WC2, June 1987. She probably had met her quota of parking tickets.

The River

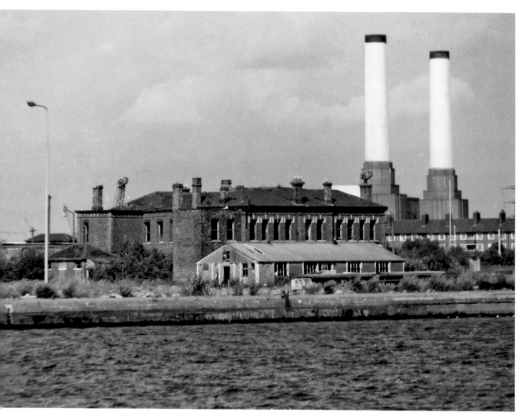

The Wood Department building at Canary Wharf with Blackwall Power Station behind. It lay on the river at Blackwall, East London. I now see the loss of the power station as a tragedy, as it had all the potential that Bankside and Battersea power stations have shown. July 1987.

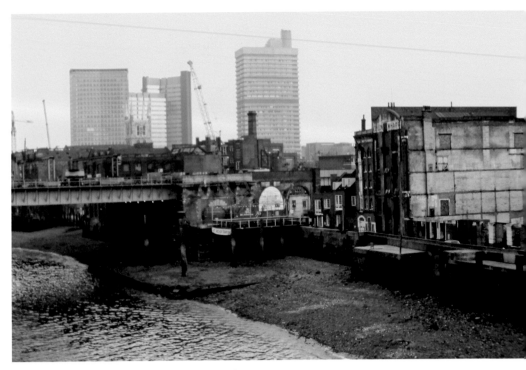

Bankside from Southwark Bridge, SE1, November 1980.

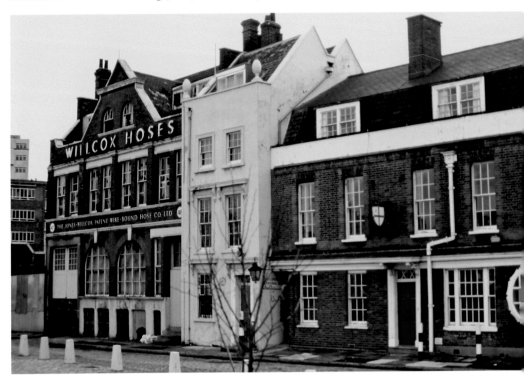

Bankside before the rebuilding of Shakespeare's Globe Theatre, January 1981.

Bankside Power Station before it was converted into the Tate Modern, January 1981.

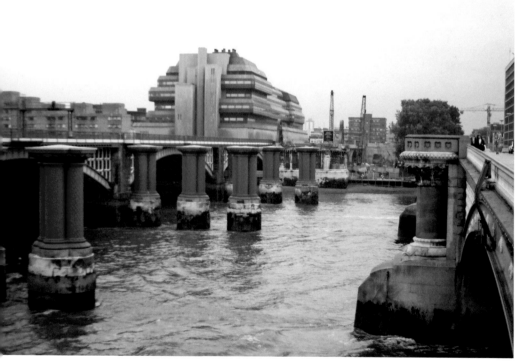

Blackfriars Railway Bridge before the station was rebuilt, July 1987.

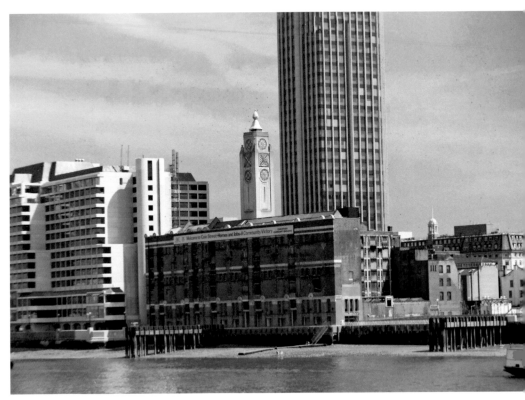

The OXO Tower area of the South Bank and Coin Street, July 1987. The OXO advert was one of the first of its kind.

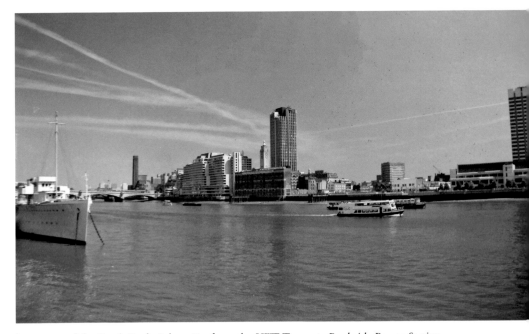

Panorama of the South Bank, July 1987, from the LWT Tower to Bankside Power Station.

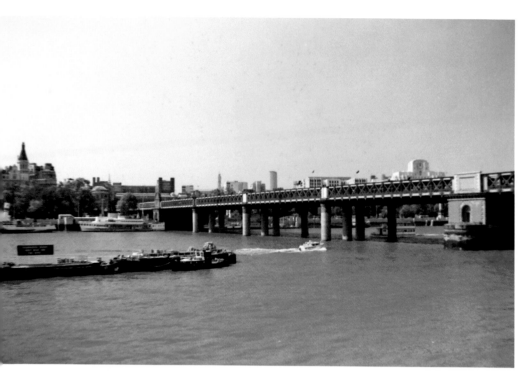

The Hungerford Railway Bridge before the addition of Golden Jubilee Bridges, July 1987.

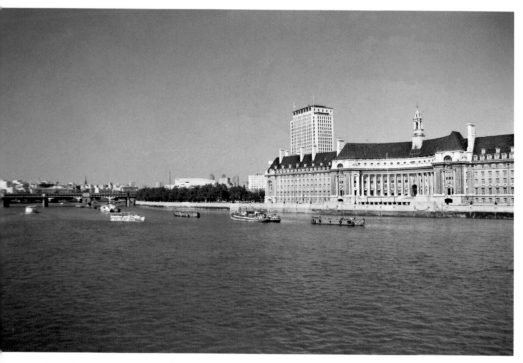

Looking from Westminster Bridge across the river towards County Hall, July 1987. It had been the headquarters of London's local government until the previous year.

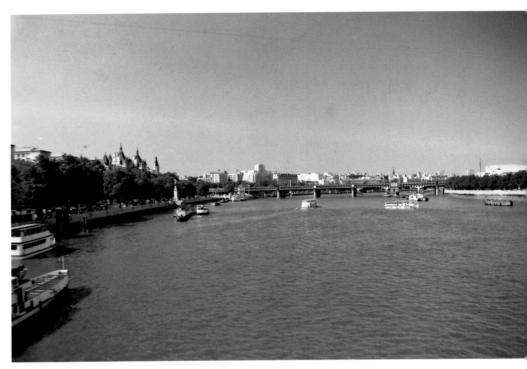

Looking downriver towards the old Hungerford Bridge from Westminster Bridge, July 1987.

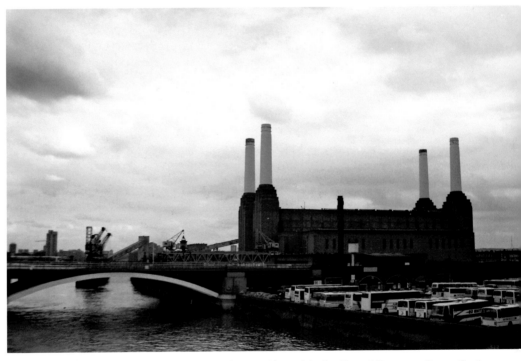

Grosvenor Bridge, also known as Victoria Railway Bridge, with the disused Battersea Power Station behind, July 1987.

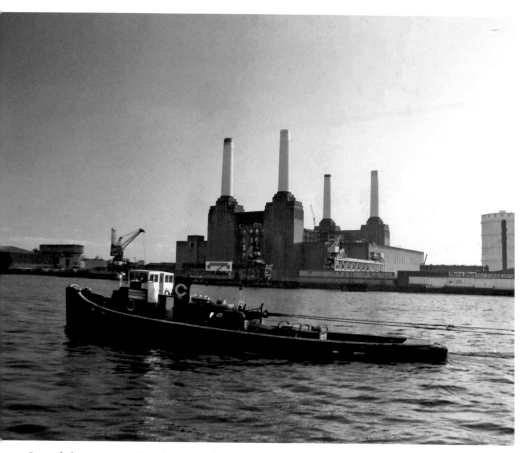

One of the many working boats on the Thames, with the shell of Battersea Power Station in the distance, January 1989.

About the Author

Tim Brown is married and lives in Essex with his family. He is due to retire in 2025 and plan to do more photography. He is trying to do more music and performance pictures, as well a the usual ones of buildings and places. A number of his images appear in the book *East En in Colour 1980 to 1990*.